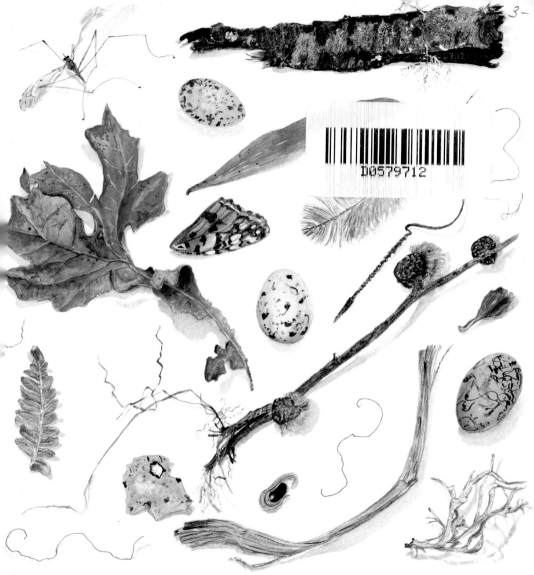

3-

D0579712

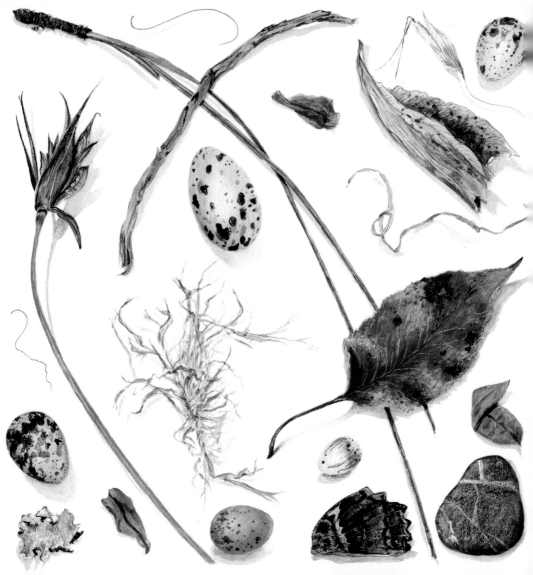

nesting instincts

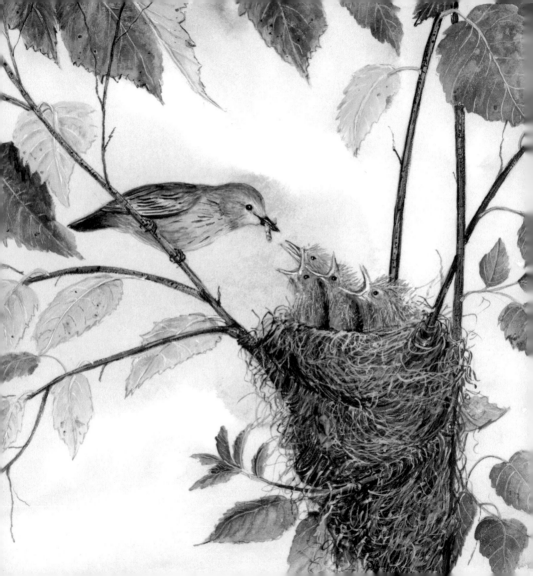

nesting instincts

A Bird's-Eye View

Maryjo Koch

Andrews McMeel Publishing, LLC

Kansas City • Sydney • London

Concept and Design: Jennifer Barry Design, Fairfax, California
Production Assistance: Kristen Hall

10 11 12 13 14 WKT 10 9 8 7 6 5 4 3 2 1

ISBN-13: 978-0-7407-8128-5

ISBN-10: 0-7407-8128-6

Library of Congress Control Number:
2009936450

www.andrewsmcmeel.com

Attention: Schools and Businesses

Andrews McMeel books are available at quantity discounts with
bulk purchase for educational, business, or sales promotional use.
For information, please write to:
Special Sales Department, Andrews McMeel Publishing, LLC,
1130 Walnut Street, Kansas City, Missouri 64106.

The nesting instinct is a deep, heartfelt need that we humans have in common with the world of birds. It is easy to see ourselves in those birds who so industriously gather the materials for their nests each spring, preparing for their future offspring.

Like humans, bird parents work hard to build their homes. Thrifty traditionalists, they use local materials: country birds employ mostly natural ones, such as twigs and leaves and mud, while urban birds recycle junk and add man-made things from their city surroundings, such as bits of paper and plastic. Like us, bird parents nurture and protect their young, often dividing up the tasks of building, hatching, and feeding. Like us, some birds, such as quail and emperor penguins, have extended families, large social structures that help to nurture the young. Like human children, baby birds are noisy, demanding, and exhausting. Like teenagers, they want to leave home and start life on their own, while at the same time they want to stay forever.

The amusing and touching parallels between humans and birds are the story of this little book. I have always loved painting the intricate textures of nests, just as I have always loved painting eggs. For this book, it was a pleasure to paint the nestlings, fuzzy with their first feathers, their eyes bright with hope, and their small bodies filled with the joy and the terror of becoming creatures of the air.

—Maryjo Koch

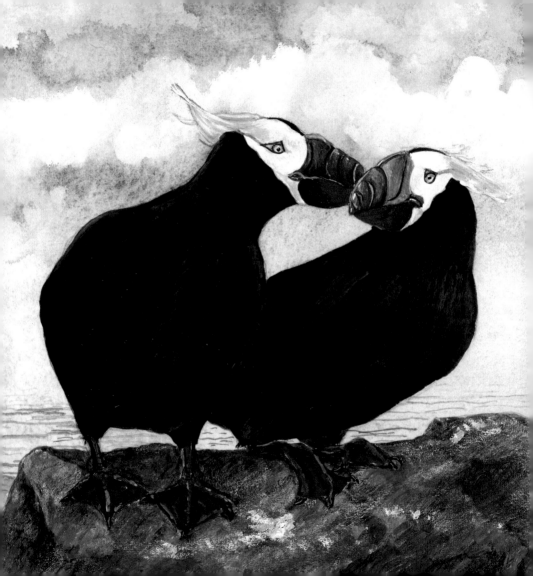

when birds of a
feather flock together,
a nest is not far
behind

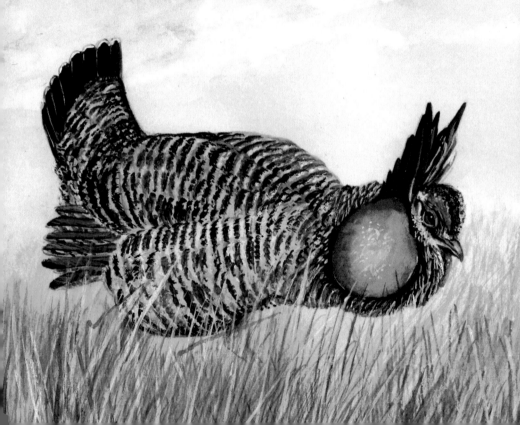

it's a quick flight from

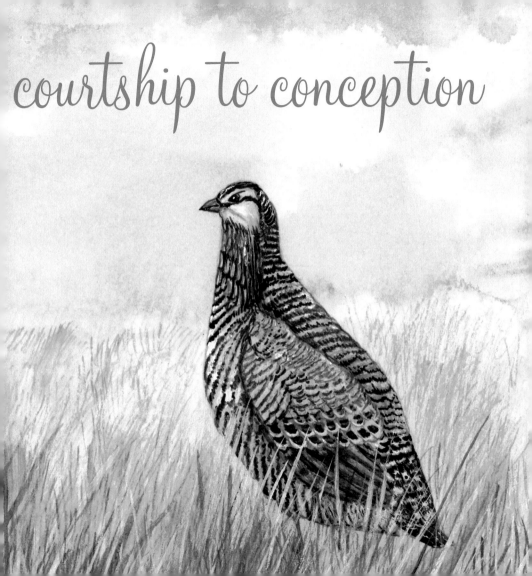

courtship to conception

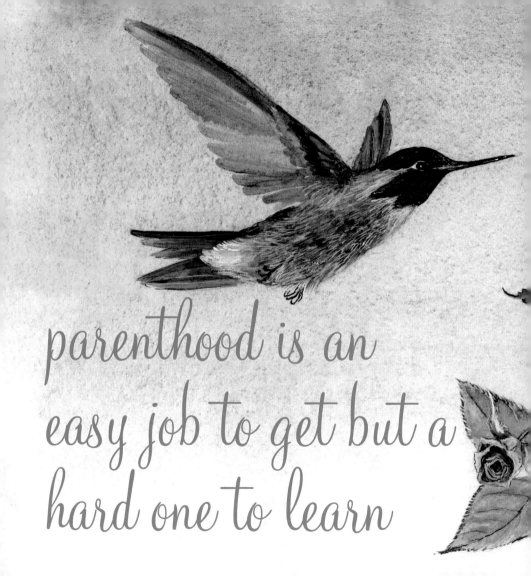

parenthood is an
easy job to get but a
hard one to learn

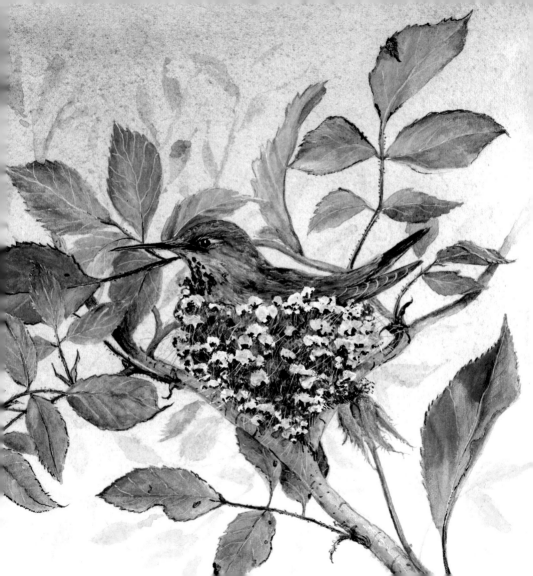

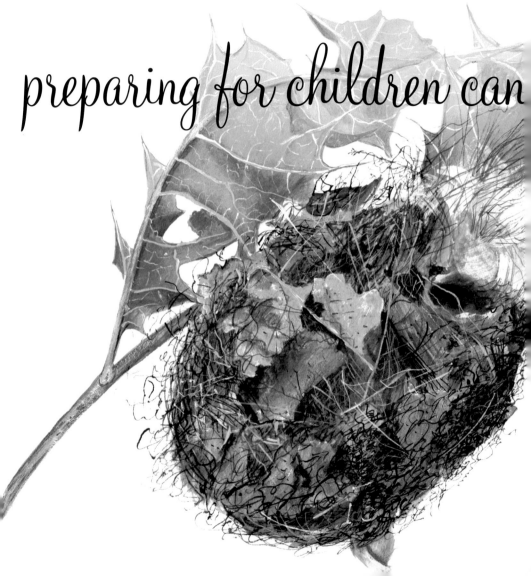

preparing for children can

turn things upside down

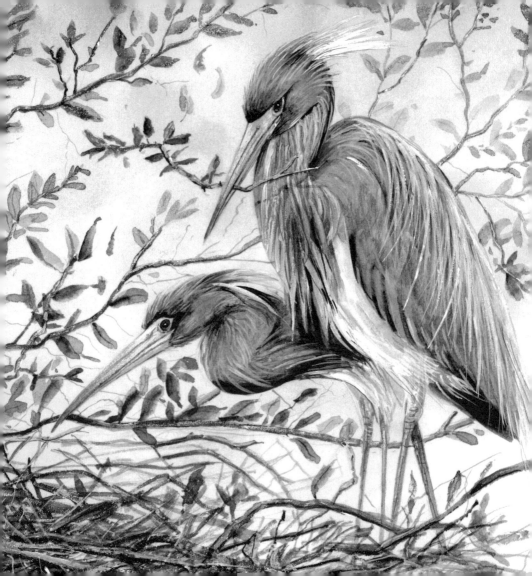

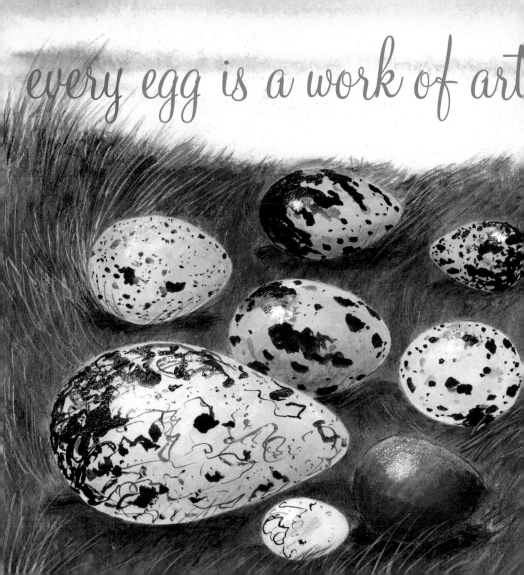

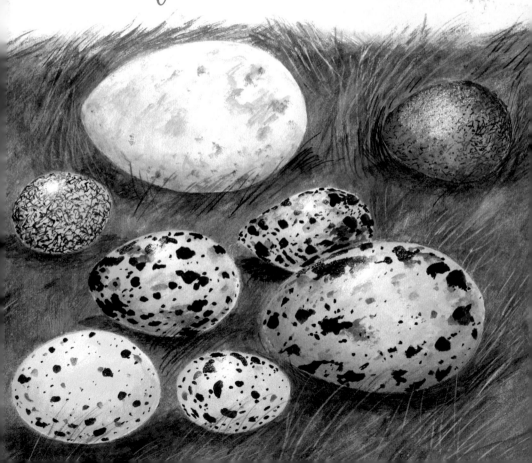
even before it's hatched

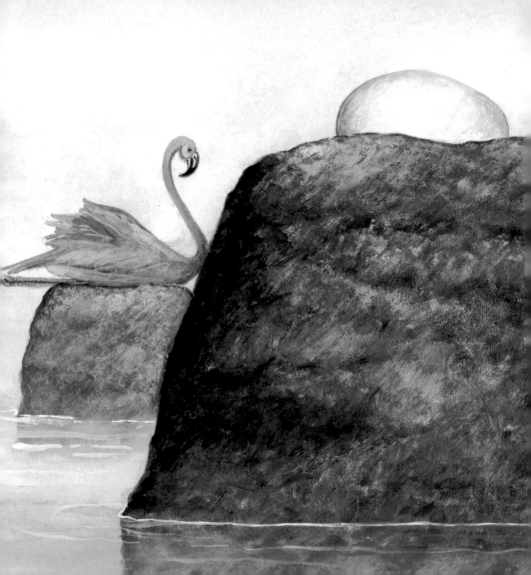

children
are a parent's
greatest nest egg
for the future

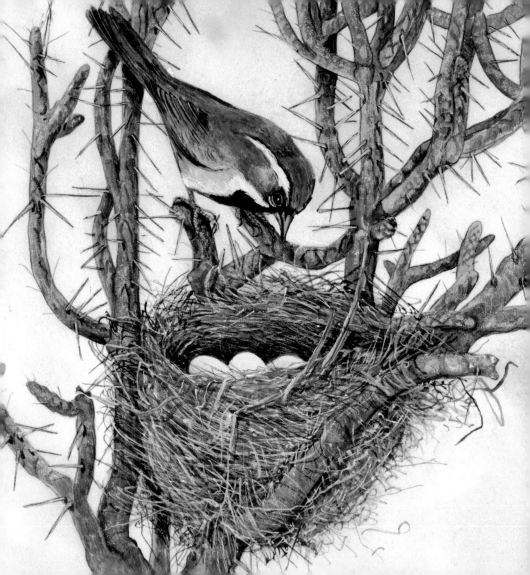

build a nest
with love,
and any bush will
be a home

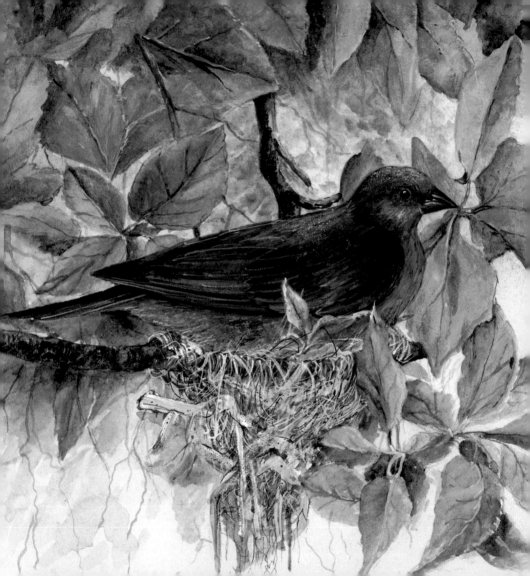

think of birth

as a search

for a larger nest

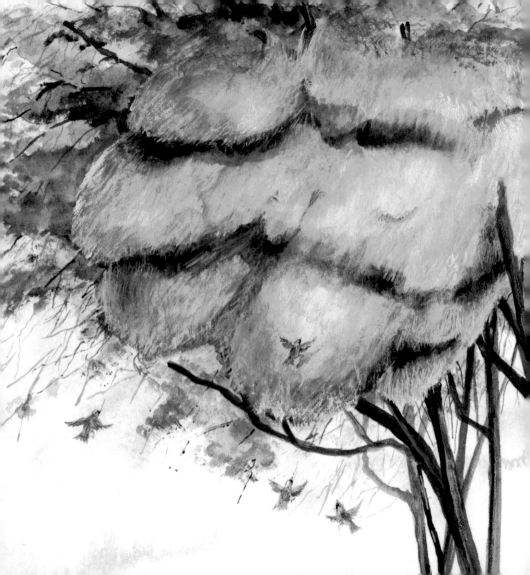

each egg
adds a branch
to your
family tree

parents
are never truly
prepared
for their chicks
to hatch

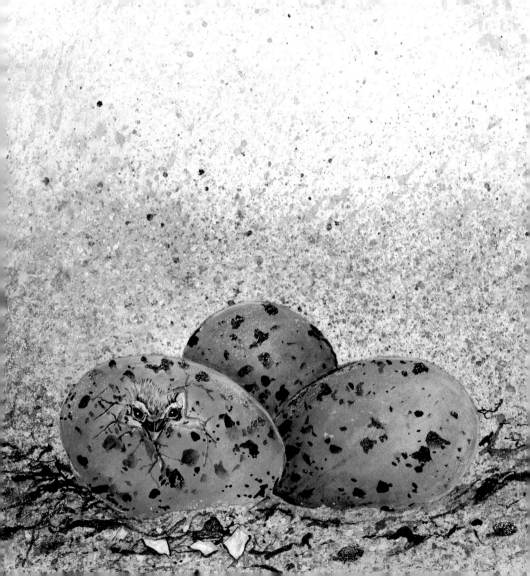

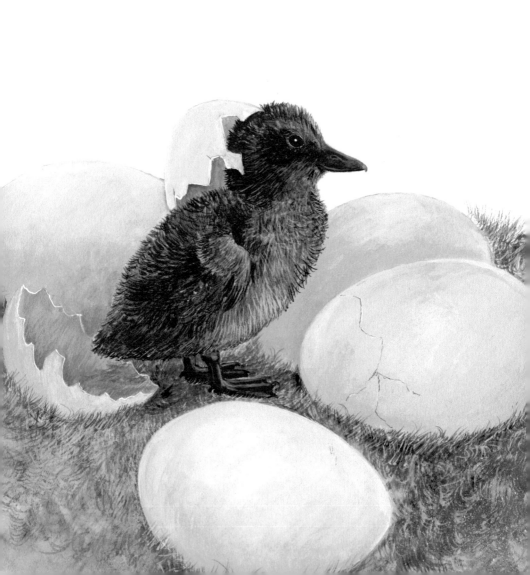

hatching
is the first of many
steps from education
to migration

babies are such a nice

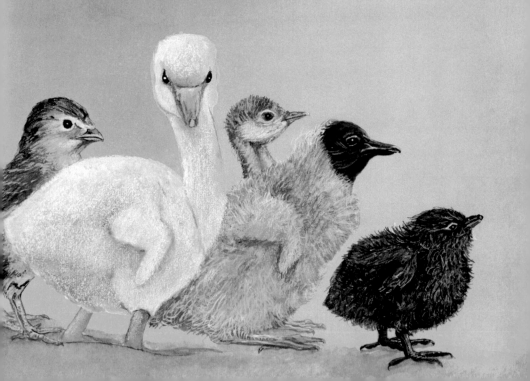

vay of starting a flock

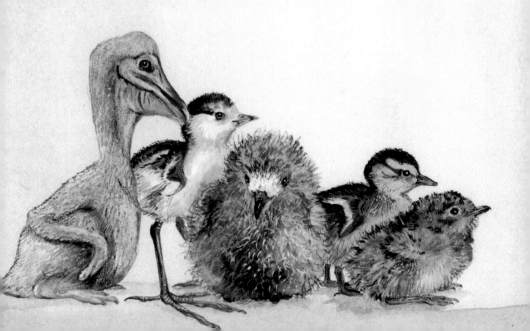

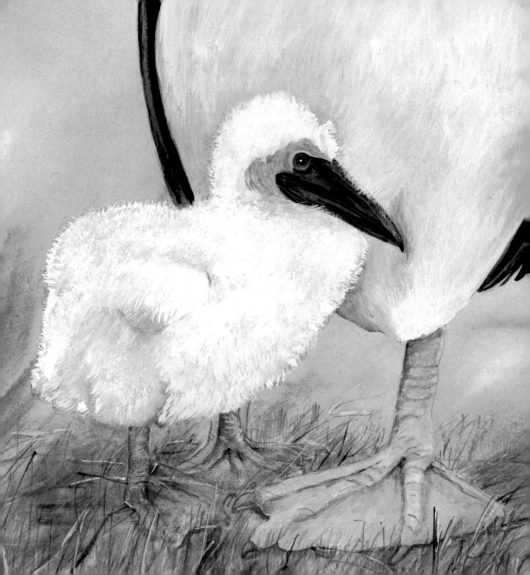

a child is born with a need to be loved—and never outgrows it

there's no such thing as a nonworking parent!

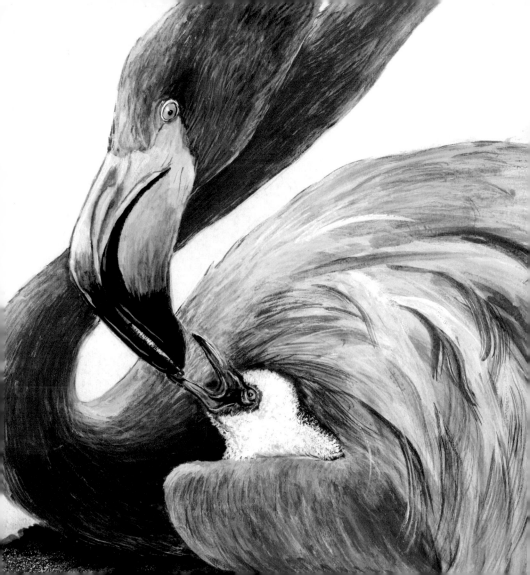

parents are full-time caregivers, as well as part-time chauffeurs

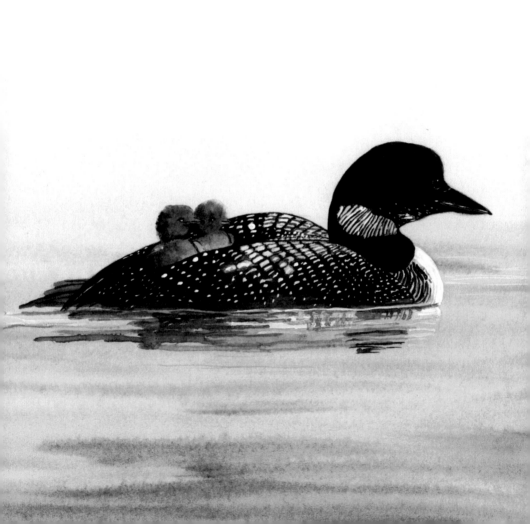

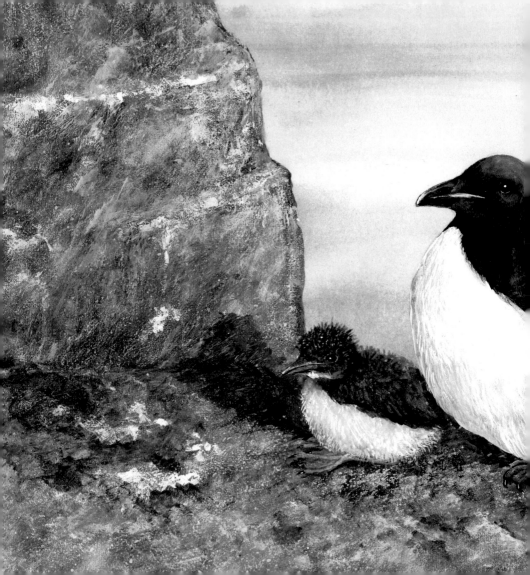

being a parent is a constant balancing act—sometimes you go over the edge

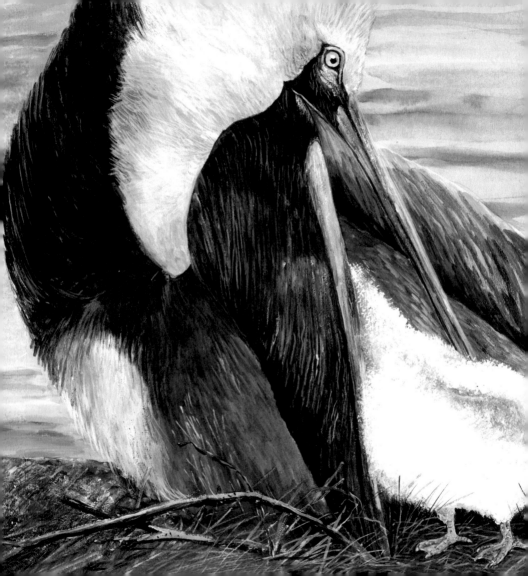

no one has the perfect recipe for raising kids

having kids
is one part love
and two parts
patience

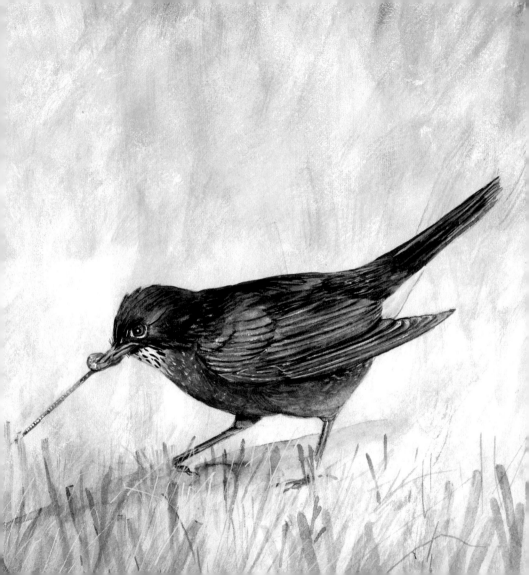

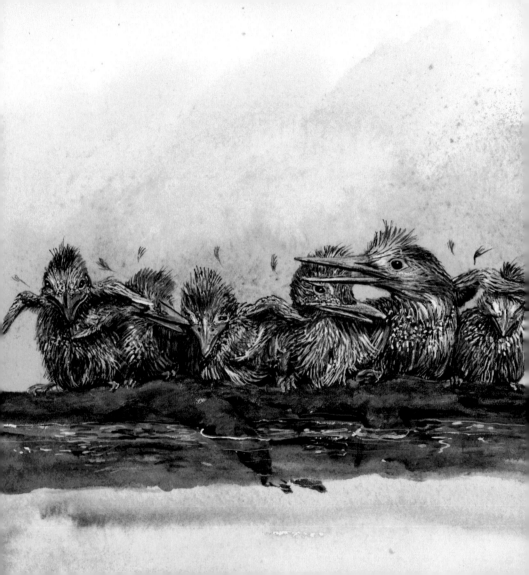

children need love,
especially when they
don't deserve it

every parent
needs a child to
teach...

...it's the way
parents learn

children follow your
footsteps
before they try their
wings

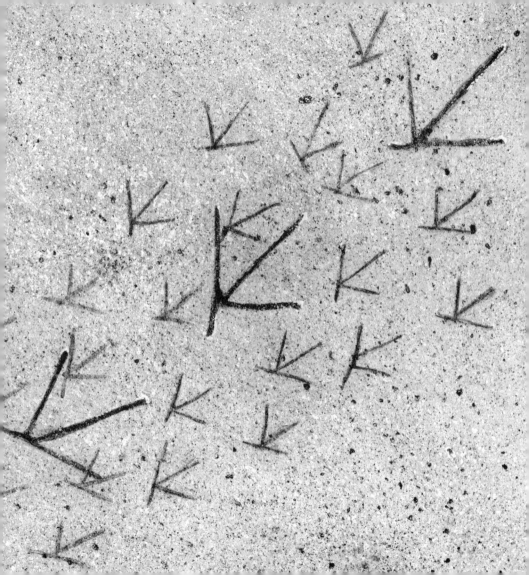

it can be scary
when it's time to
fly the coop

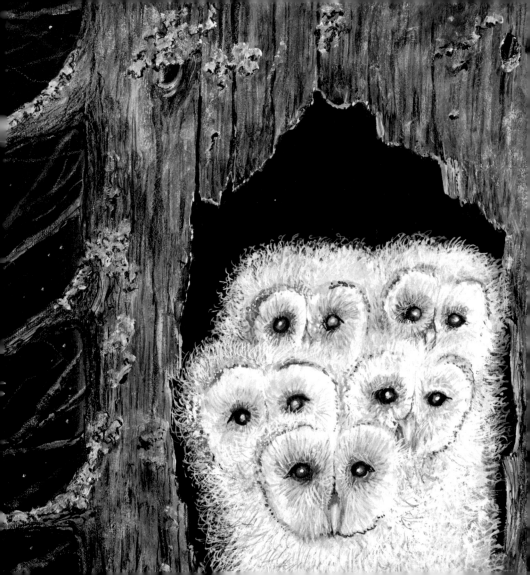

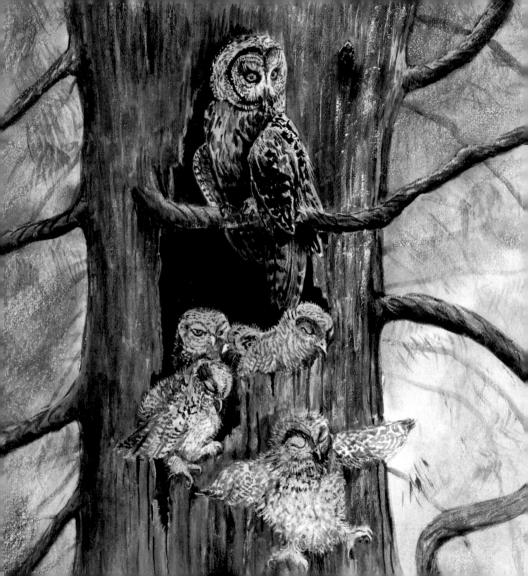

learning to fall
is part of
the flight school
of life

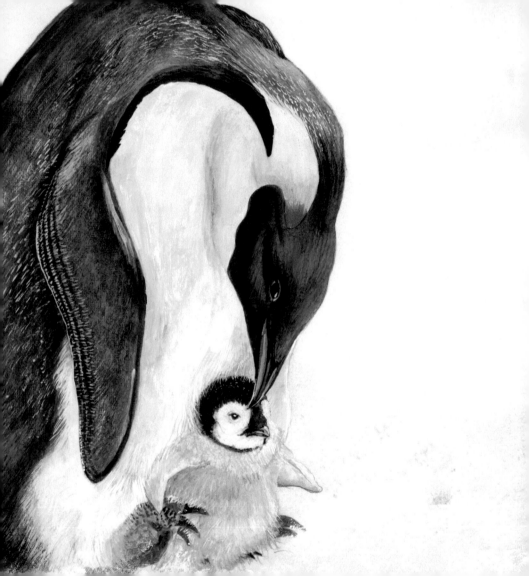

the greatest gift
parents can give their
kids is to let
them stand on their
own two feet

About the Birds

Northern Cardinals (cover)
Brightly colored male cardinals are doting husbands to their expectant mates. Males feed the females food and protect their nesting territory from intruders during the egg-laying and incubation periods. Although only the female cardinal builds the nest and incubates the eggs, the male helps bring nest-building materials to her and keeps a close eye on her and the surrounding territory for predators and other males. After working together to create a home for their young, both parents feed and care for the new hatchlings until they're ready to leave the nest.

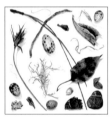

Nesting Materials (endpapers)
Nests, both large and small, are built from an endless variety of natural and man-made materials. The most common materials come from nature, such as bark, leaves, pine needles, grass, stones, seashells, lichen, ferns, feathers, animal fur, insect carcasses and wings, flower petals, branches, and seed pods.

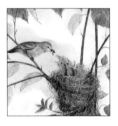

Yellow Warbler and Chicks
Yellow warbler parents are always on the move, as they have many mouths to feed once their clutch of three to seven eggs is hatched. While nest building and egg incubating are done by the mother, both parents take turns feeding their noisy hatchlings a steady diet of insect larvae. Even though the chicks are ready to fly the coop within eight to twelve days, the parental feed train may extend to two or more weeks after the young leave the nest. Some of the fledglings may follow the mother, while the rest remain with the father until they are ready to be on their own.

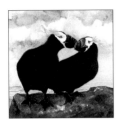

Tufted Puffins

Tufted puffins are seabirds native to the coastal areas of the northern Pacific. They form long-term pair bonds and nest in burrows at the edges of cliffs, on grassy slopes, and in natural crevices in rocks. Puffins court by rubbing bills, which are brilliantly colored only during breeding season. Digging the nest burrow is a time-consuming job, and the birds usually do not breed in the same season in which they dig the burrow. When the pair finally breeds, the female lays one egg, which both parents incubate and then care for.

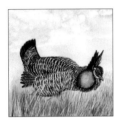

Greater Prairie Chickens

Greater prairie chickens are best known for their unique territorial mating ritual, called booming. Hoping to attract the females, the males gather to perform a colorful display where they raise earlike feathers above their heads, inflate orange sacs on the sides of their throats, and stutter-step around while making a deep hooting moan. Sometimes, the performance can go on for more than a month before one or two of the most dominant males end up winning over 90 percent of the females.

Anna's Hummingbirds

Because hummingbirds must spend a lot of their time finding and feeding on flower nectar, they are for the most part unsociable. Male and female hummingbirds do not form a pair bond after mating, but unlike most hummingbirds, the male Anna's hummingbird sings during courtship. The mother builds a small nest about 1½ to 2 inches in diameter and lays one to three white eggs in a tiny woven cup of small twigs and lichens fastened onto a sheltered horizontal limb.

Yellow-Bellied Sunbirds

In all species of sunbirds, only the female builds the nest. As she builds, the male chases her back and forth, singing lustily. As the female sunbird comes to her nest with nest material, the male becomes so excited that he often swings upside down, singing and swaying. Sunbird nests are woven together with cobwebs that create a weblike holding ground for the other nesting materials the female will collect, such as dead leaves, grass, twigs, lichen, and moss.

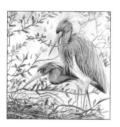

Tricolored Herons

Expecting tricolored heron parents are role models of cooperation: Both mother and father help build the nest, both help incubate the three to four light blue–green eggs, and both parents alternately feed the newly hatched chicks. These herons breed mainly along the Gulf and Atlantic coasts of the United States, and build nests in mangrove or buttonwood swamp forests, or in thickets of tidal marshes. The eggs are laid on a platformlike nest of stems and twigs that is occasionally lined with grass. Herons are highly sociable, nesting in large colonies.

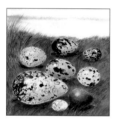

Eggs

Nature carefully determines the optimum number of young that can be successfully raised by each species. Too few eggs, and inevitable accidents threaten the entire clutch. Too many, and the female may become too weak to survive the winter. Where the environment will support larger populations, parent birds "sense" it, and the number of eggs laid is adjusted accordingly.

Greater Flamingo Nest Egg

A flamingo nest is nothing fancy, just a mound of mud about a foot high, built in a coastal marsh. The nest needs to be high enough to protect the egg from flooding and from occasional intense heat at ground level. The top of the nest is saucerlike, and cradles a single 3- to 3½-inch egg. Flamingo pairs usually mate for life, and both the male and female build the nest and incubate the egg by straddling the nest with their long legs folded. Incubation takes about one month. Once hatched, a flamingo can live for up to twenty years in the wild.

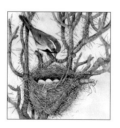

Black-Throated Sparrow

Also called the desert sparrow, the black-throated sparrow is native to the inhospitable desert hillsides and scrublands of the southwestern United States and Mexico. Despite the heat and arid extremes of its habitat, it builds a loose nest hidden in thorny bushes or shrubs to protect its eggs from desert predators. The nest is made of grass twigs, plant fibers, and animal hair, and comfortably cradles two to four white or pale blue eggs. The female incubates the eggs, but both parents feed the hatchlings, which leave the nest after twelve to fifteen days.

Brown-Headed Cowbird

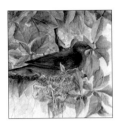

Instead of making a nest of her own, the female cowbird lays her eggs in the nests of other bird species. The mother cowbird abandons her newly laid eggs to the new host, who generally can't distinguish the cowbird's eggs from its own. The young cowbirds are raised by its foster parents, usually at the expense of at least some of the hosts' own chicks. Cowbird eggs hatch and develop faster than the eggs of other species, which gives cowbird nestlings a head start in getting food and attention from their foster parents.

Social Weavers Communal Nest

Social weavers build enormous thatched communal nest structures in trees in the deserts of southern Africa. One of these apartment house–like nests can accommodate hundreds of birds. The large straw nest offers better protection in the desert than a small single nest, plus it is well insulated from the desert's heat in the daytime and from the cold at night. While some of the structure's chambers are for nesting, many serve as lodging. The nests can last for decades and are continually enlarged as new inhabitants come and go.

Herring Gull Hatchling

The herring gull lays from two to four eggs on the ground or on coastal cliff ledges in large colonies. Incubation lasts about four weeks, and the vulnerable eggs are strongly defended by both parents against numerous predators. Just before hatching, the tip of the chick's bill is equipped with a small, hard excrescence called the egg tooth. When the chick is ready to hatch, it raises its bill so that the egg tooth comes into contact with the shell and pushes up a small "pip," a crack in the shell that allows the chick to eventually break free.

Common Eider Hatchling

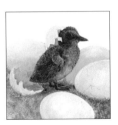

A bird egg is a wondrous balance of strength and delicacy. It must bear the weight of an incubating parent, yet be thin enough that the hatchling can free itself. When the eggs of common eiders hatch, the mother and any nonbreeding females gather around the newly born ducklings in order to protect them on their first trip to the water. The downy hatchlings leave the nest within twenty-four hours and feed themselves as they learn to dive within one hour of entering the water.

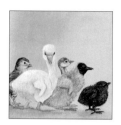

Bird Babies (left-hand page)

From left to right: Wild turkey, flamingo, whooping crane, black vulture, American coot. Babies come in all shapes and sizes. Whatever the kind, a baby is born with a need to be protected and cared for.

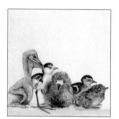

Bird Babies (right-hand page)

From left to right: Pelican, northern jacana, petrel, northern shoveler, Sabine's gull. All these babies have something in common—they will all grow up to live near the sea.

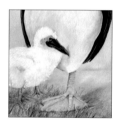

Brown Booby and Chick

The brown booby typically lays only two chalky blue eggs during its breeding season. One egg serves as an "insurance policy," as the first offspring to hatch competes with the other and often pushes it out of the nest because there is not enough food to go around. Boobies incubate their eggs beneath their feet. They breed and nest in large colonies on inaccessible cliff edges or slopes on remote islands and coasts in the tropical regions of the Atlantic and Pacific oceans.

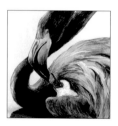

Greater Flamingo and Chick

A newly hatched flamingo chick has light gray down feathers, a straight pink bill, and swollen pink legs. The chick stays in the nest for five to twelve days, being fed by both parents. Its food is a type of "milk" called crop milk, which comes from the parents' upper digestive tract. Once the young birds leave the nest, they gather with other fledglings in large groups called crèches, accompanied by flocks of adults. Their pink or reddish color comes from the rich sources of carotenoid pigments in the algae and small crustaceans that the birds eat as they mature.

Common Loon and Chicks

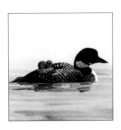

Newborn loon chicks often ride on their parents' backs for the first two weeks until they are ready to swim on their own. The newly hatched chicks resemble fluffy dark brown balls. When ready, they take to the water with their parents, swimming feebly at first. Loons breed across northern North America into Greenland and Iceland and come to land to lay two large dark brown eggs heavily spotted with black. Their nest is made in a crude depression only a foot or two from the water, and is lined with whatever vegetation is available.

Thick-Billed Murre and Chick

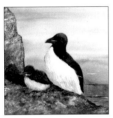

Murres nest on narrow ledges on precipitous cliff faces in the coastal regions of the northern Arctic. They make no nest, instead laying a single egg on bare rock. Murre chicks mature rapidly and are ready to fly and swim three weeks after hatching. Even when they are able to jump off high cliff ledges and plunge into the frigid ocean below, they remain with the male parent, who continues to feed them for another month before they begin migrating south in large colonies.

Brown Pelican and Chick

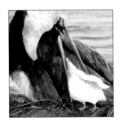

The brown pelican has a long gray bill with a large pouch of skin underneath. The pouch can hold almost three gallons of fish and water! Pelican parents provide their chicks with food that only a baby pelican could love: regurgitated fish deposited onto the bottom of the nest for the first ten days after hatching. After that, the chicks will dunk their tiny heads into their parents' bill pouch and eat the regurgitated food right from their parents' bills until they are old enough to plunge-dive for fish on their own.

American Robin

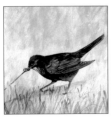

Robins are famous for being expert foragers of earthworms, insects, and berries. They can also produce three successful broods in one year. The mother robin continues to feed and brood the chicks while they are very young. Baby birds leave the nest about two weeks after hatching. But even after leaving the nest, the young birds follow their parents, begging for food. About two weeks after fledging, young robins become capable of sustained flight and begin foraging for food on their own.

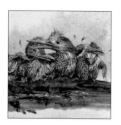

Belted Kingfisher Chicks

When belted kingfisher chicks are ready to leave their waterside nest burrows, they are coaxed out of the burrows by their parents with their favorite food: freshly caught fish. They will then follow their parents to a waterside perch with the hope of more fresh fish to come. For nearly a month, kingfisher siblings compete for food served to them by their busy parents, as they each require eight to eleven minnow-sized fish per day. Kingfishers are a noisy lot, giving loud, rattling calls to mark their territorial fishing grounds.

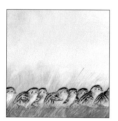

California Quail and Chicks

California quails are very sociable birds that often gather in small flocks known as coveys. Their nests are shallow depressions in the ground lined with vegetation and camouflaged under a shrub or other ground cover. The female quail usually lays around twelve eggs. Once the babies hatch, they associate with both parents and each other. Often, quail families group together into communal broods that include at least two females, multiple males, and many offspring.

Common Snipe Tracks (parent and chicks)

Native to all parts of North America and northern South America, the common snipe is a small, stocky shorebird that lays a clutch of four olive-brown eggs boldly patterned with brown and black spots. As the eggs hatch, the newly hatched chicks follow the male out of nest; he feeds and protects them while the female continues incubating and feeding the remaining hatchlings. After about twenty days, snipe chicks are ready for their first flight.

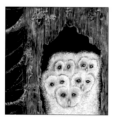

Barn Owl Chicks

Barn owl parents are excellent nocturnal hunters, easily able to locate prey for their hungry chicks with their excellent low-light vision and exceptional hearing. Both parents leave the nest nightly to hunt for food to feed their young. After about seven weeks, the chicks are fully fledged and will remain in the vicinity of their nest for about a week or two to learn hunting skills from their parents before rapidly dispersing from the nest area.

Great Gray Owl and Chicks

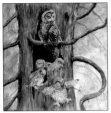

Great gray owls do not build nests, but instead will use nests previously occupied by another large bird or will make a nest out of a large tree cavity. The female guards the young and feeds them food brought by the male. Once the soft down of the owlets is replaced with spotted gray feathers, the owlets begin preflight exercises by walking around the top of their nest flapping their wings. After three or four weeks, the fledglings begin to jump or fall from the nest and will eventually start to fly one to two weeks later.

Emperor Penguin and Chick

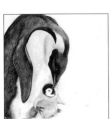

No other parents in the bird kingdom must raise their young in such harsh conditions as the emperor penguin. After laying a single large egg, the emperor penguin does not make a nest in the barren, icy Antarctic terrain. Instead, the female places the egg on top of the male bird's feet, where it is cradled snugly beneath a patch on his belly called a brood pouch; his body heat keeps the egg warm. Thousands of duty-bound male emperors huddle together for extra warmth during the grueling two-month incubation of the eggs. During this time, females feed in the icy Antarctic waters, but return just before the hatching to relieve the males. After the chick hatches, the parents then take turns, one keeping the chick warm while the other forages at sea for food. The chick is cradled from the freezing ice on the feet or sheltered in the brood pouch of one of its parents until it is old enough to be on its own, huddled in a group of several thousand other chicks six to seven weeks after hatching.

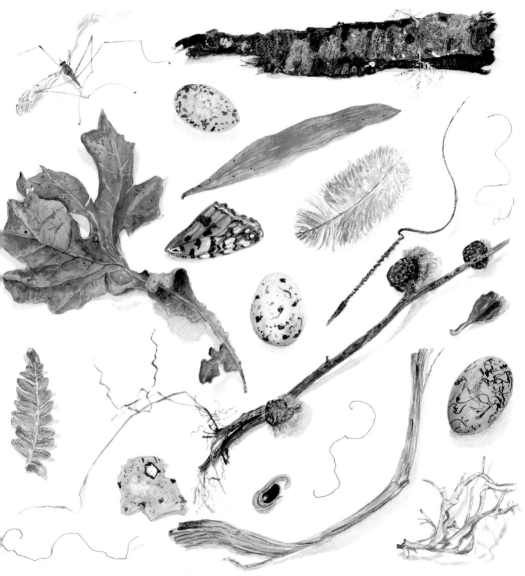

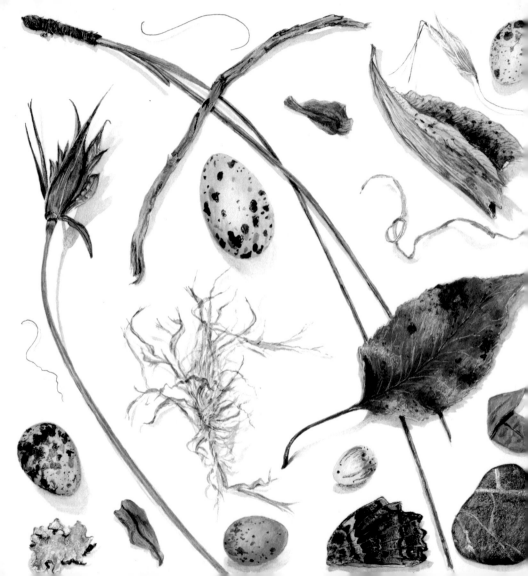